Also by Harold Green
Black Roses

BLACK OAK
Odes Celebrating Powerful Black Men

HAROLD GREEN III

ILLUSTRATIONS BY MELISSA KOBY

HARPER
DESIGN
An Imprint of HarperCollinsPublishers

BLACK OAK

HarperCollins books may be purchased for educational, business, or sales promotional use. For information please email the Special Markets Department at SPsales@harpercollins.com.

First published in 2022 by
Harper Design
An Imprint of HarperCollins*Publishers*
195 Broadway
New York, NY 10007
Tel: (212) 207-7000
Fax: (855) 746-6023
harperdesign@harpercollins.com
www.hc.com

Distributed throughout the world by
HarperCollins*Publishers*
195 Broadway
New York, NY 10007

ISBN 978-0-06-313556-7

Library of Congress Control Number: 2021051648

Book design by Janay Nachel Frazier

Printed in Canada

First Printing, 2022

THIS BOOK IS DEDICATED TO TWO OF
MY BEST FRIENDS AND BIGGEST
INSPIRATIONS, ZAIRE AND ZULU.
MAY YOU BOTH GROW TO BE BLACK OAKS.

CONTENTS

INTRODUCTION

Very early in my life, I could feel how influential Black male role models were for me, external and immediate ones. Just as much as I was inspired by Dr. Martin Luther King Jr., Malcolm X, Nelson Mandela, and Michael Jordan, I was equally impressed by my father, grandfather, uncles, cousins, and coaches.

My father's writings were my initial introduction to poetry. He would write poems for my sister and me and often call us Princess and Prince, affirming and reminding us how powerful and regal we were. It was such an endearing act, and the inclusion of those regal themes subconsciously built us up in a way that nothing in the world could ever decrease our self-esteem. We were always reminded that we were heirs to whatever kingdom we so desired. He also birthed a certain passion in me for music. The way certain songs moved my father was different from what I had seen from anyone else around me. I learned that music is a language and not just a source of entertainment.

My grandfather Harold Green Sr. is a very clean man. He is a vintage southern gentleman from New Orleans. Even his yard clothes are pressed and proper. His house was the gathering spot for his block, and he was the handyman, cook, and peacekeeper for the neighborhood. My grandfather introduced me to the importance of community. Both my father and grandfather showed me the value in just saying hello with a smile and helping when our services are needed; my grandfather specifically, and unknowingly, demonstrated to me that the community will take care of you if you take care of it.

My uncle Marvin was the first person I knew with rims and a sound system. He would pick me up in his gray Chevrolet Trailblazer, playing

Tupac or Bone Thugs-N-Harmony, and I thought I had been transported into a John Singleton film. He played every sport I aspired to, loved the University of Michigan, kept a fresh pair of Jordans, and would often take me to the barbershop. He introduced me to what was "cool." My uncle Reggie would take me to the Art Institute of Chicago, speak about films I had never heard of, and always had some statement art piece on his wall. He introduced me to a certain liberation of being a Black man with a love for the arts, allowing me space to be more open-minded. Being exposed to fine art early on helped me appreciate it, create it, and relate to those who love it as well.

One of the most important lessons I learned from the men closest to me is the value of friendship. I knew my father, grandfather, and uncles had lifelong friends who always seemed to bring them joy. I watched from a courtside view how significant those friendships were to them as they laughed and confided in one another. It seemed to me that one of the most crucial resources these friendships provided was not just joy but a sense of comfort. To know and be known for decades, and still be loved for who you are, when you have stood at your tallest and fell to your lowest, is an incredible feeling. I know. I learned very early how critical friendships are for Black men to not only survive but to feel understood as well.

I have made long-lasting friends with other Black men at every stage of my life. Carlton in elementary school, along with our best friend Joshua, were the first sleepover crew I had. We navigated the Chicago streets and the public school system at such a formative age while creating memories I will never forget. In middle school there was Kerel and Excell. I met Excell when I moved to the south suburbs of Chicago at the start of middle school. When my mother acquired a job near our new home and could no longer transport me into the city every morning, Excell's father gladly offered to take me to school every day for the next two years. Excell and his dad are among the most gracious people I have ever met.

There are my homies from high school: Orlando, Mike, Danny, Brandon, Dave, Ronnie, and Eric. They each have their own stories that I think could be their own books, but the way that we looked after each other, made each other laugh and feel protected during those four years, will forever remain in my heart. My college roommates Steve, Ed, and Larry at Grambling State each believed in me and my dreams of becoming a professional artist and agent of change on campus, and they gave me the confidence of ten men.

Making long-lasting friends as an adult can be tricky, but not with Binkey, Malari, Adrian, Bradley, Pierre, and Paul. Binkey and Malari were the first brothas I met on the open-mic scene in Chicago, and two of the most talented. They are older than me but never held back on complimenting me or including me. Adrian and Bradley are both renowned photographers who saw me for me so quickly and so well. Their lenses are still just as sharp today. I've known Pierre since Grambling, and he has since become one of the most reliable friends I have. And while I've known Paul since middle school, the man he is today is what makes me proud to call him my friend. He has shown me how inspiring growth can be, and how loving someone more than yourself can be so powerful—leading to more love in your life.

I have realized how essential it is to communicate with these men for our friendships to continue and thrive. I tell each one of these Black men, "I love you," because sometimes we forget how important it is to hear that and be reminded of that in a nonromantic relationship. To know that you are valued just for existing and striving to be your best self is a relief in an often stressful and dismissive world. These men are fathers, brothers, professionals, community advocates, partners, dreamers, and friends, and I have had the honor of discussing the wholeness of these men with them. What a pleasure. They do not run from the love I have for them, or the

power it has to change them, and that is beautiful. They are beautiful. As a friend, I am the listener, affirmer, storyteller, and celebrator. Those are a few of my superpowers, and I really hope to put them on full display in this book.

I wrote *Black Oak* because I want to expand on the language that Black men use to speak to and about each other. One thing I've learned in all my friendships is how to be comfortable affirming other Black men and how imperative it is to cheer each other on when we are pushing the narrative forward. Every Black man in this book has intentionally put his Blackness on display, went out of his way to uplift or assist other Black people, or knew his Blackness was a part of the grading rubric for his success and never tried to erase it. Those characteristics alone, in addition to being outstanding humans in other ways, is worth cheering for.

I want us to be more comfortable rooting for each other no matter sexual orientation, disagreements, or status. Whether we admit it or not, there is an extra level of special that we feel when we are acknowledged by our brothas. Black men have an unspoken language that exists in the types of handshakes, head nods, and compliments that we give each other. I love our cryptic union, but I also believe in the power of clarity. I wanted to look my brothas in the eye and tell them they are special and deserving of so much more with this book.

This project was mentally conceived shortly after *Black Roses* because I love balance and because I knew how inspiring it would be. I have not seen many, if any, projects like this, and I truly believe that if I had come across something like this growing up, I would have been inspired. I would have wanted to be a Black Oak. One of the most special memories I have while rolling out the digital campaign for this project before it became a book was watching Dwyane Wade repost the video I did in honor of the excellent job he is doing as a father. The way he has decided to love his

child became the center of many negative and hateful opinions of what being a father should look like. As a brotha with two children of my own, I wanted to celebrate him in this way to combat those who were presenting the opposite energy.

As I wish with *Black Roses*, I would love to see *Black Oak* turn into volumes of works because I can't see this topic being superfluous in the foreseeable future. But what I hope you do with this collection is look further into each of these brave and dedicated men yourself. I know someone's story will touch you in a way that you weren't expecting. Even with the figures whom you may already know a lot about, take a deeper dive. I call the research I did for each person in this book "sitting with them," and I gained so much emotional and biographical insight. I hope you sit with some of them, too. I also listened to a John Coltrane compilation titled "Work from Home" every time I sat down to work on this book. I'm not saying that you have to do that, but if you feel moved to do so, it may enhance your experience while reading this book or researching these men.

As Black men in America, we have enough hurdles to clear. I want this book to help show us how unity and brotherhood can help us not only clear those hurdles but assist us to soar higher than we imagined. So let's help these Black men soar by lifting up their names now:

Barry Jenkins, Big K.R.I.T., Billy Porter, Black Thought, Chance the Rapper, Charles Booker, Colin Kaepernick, Dr. Henry Louis Gates Jr., Dr. Marc Lamont Hill, Dwyane Wade, Edmund Graham III, Eric Hale, Excell Hardy Jr., Harold Green Jr., Harold Green Sr., Hebru Brantley, Jamaal Bowman, Jason Reynolds, Jericho Brown, John Legend, Kehinde Wiley, Kerry James Marshall, Kevin Fredericks, Killer Mike, Kylar Broadus, LeBron James, Mahershala Ali, Matthew Cherry, Orlando Cooper, Pharrell Williams, Rev. Dr. Otis Moss III, Rev. Dr. William Barber, Ryan Coogler, Swizz Beatz, Ta-Nehisi Coates, Theaster Gates, Tobe Nwigwe, Tristan Walker, and Tyler Perry.

BRAVE HEARTS

MR. PORTER'S POWER

ODE TO BILLY PORTER

What a Herculean feat
to break apart stereotypes,
then build yourself back up
after the fight of your life.

With your past, present,
and fantastical future.
But Billy is a believer,
a fighter,
and a doer.

You turned
what they called liabilities
into assets.

Demolish the antiquated ideals of manhood,
but make it fashion.

Shine on 'em, Sun God.
May a little of your gold
fall on their tongues
so they never speak so cheap again.

Spread your wings,
show us your cape,
teach us fly.

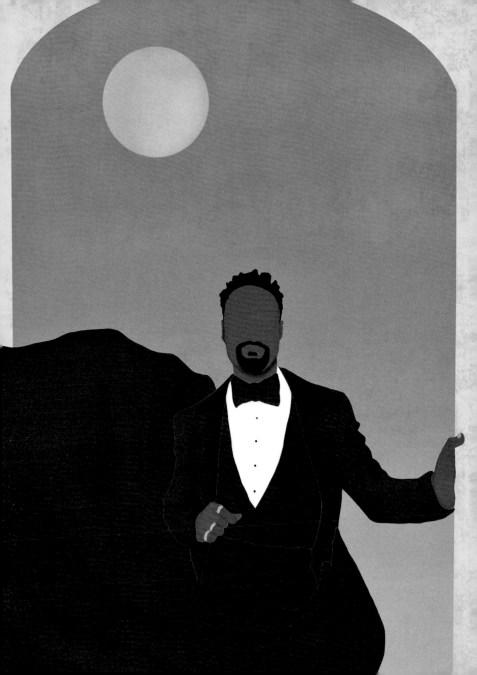

May a little of your glitter
fall upon their eyes
so that they appreciate
the finer things.

Be the ying
and the yang.

Show us
how boldly you've mastered balance.

Show us
how to conquer our fears,
but make it fashion.

Blur the lines
by continuously stepping over them—
in your pumps.

Remind them
you are not spectacle.
You are talent.

When you stand on that red carpet,
you are not timid—
you are tower.

You are present
and that's power.

BLACK THOUGHT PROCESS

ODE TO BLACK THOUGHT

The Tyrant, Mr. Trotter:

I've never seen
someone make bullying
look so beautiful.

The fine art
of being a backbreaking boss.

The way you make words
work for you.
As soon as they punch in
they get punched in the mouth.

Folding over
and contorting
to your demanding delivery.

Finding a way to fit
to your form.
Function finds flexibility.
Nimble becomes the norm.

The words behave in a way
that make me believe
that even though

you rip them apart
with barbaric force—
just to build them back up
to new structures
of their past standard,
they don't want to let you down.

I don't know
if it's Stockholm syndrome,
but those battered exiles
flung from your tongue's island
sure are fond of you.

I've never heard
them sound so precise.
As demanding as you are,
they should be thankful for you;
because I just don't recall
them ever working that well.

I think we can all learn a lesson
from the way
you have taken jurisdiction
over your diction.

The lesson?
The words work for you,
so be wise in how you employ them.

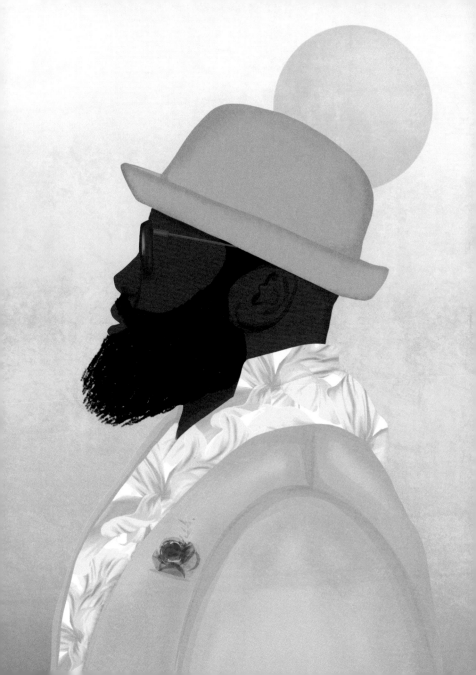

COLIN'S PROPOSAL
ODE TO COLIN KAEPERNICK

We are programmed to believe
when a man gets on one knee
that he is proposing.

We also feel secondhand embarrassment
when that proposal is rejected.

Sometimes, we even find ourselves
in an unwarranted rage:
"How could they say no?!"

On September 1st, 2016,
Colin Kaepernick proposed to the United States—
she said, "No."

Very few were embarrassed,
but many were enraged—
at the rejected,
not the rejector.

But that's the privilege
of the oppressor,
to be absolved of accountability.

Colin proposed humanity for all—
but, nah.

It's amazing, a man responsible
for so many first downs
would have to take the fall.

And haven't we seen this before?
Mahmoud Abdul-Rauf
Muhammad Ali
Craig Hodges
The Syracuse 8
John Carlos
Tommie Smith
Bill Russell

That list too Black for me.
As if, when you Black
you can't believe
that your amendments shouldn't have amendments.

All this posturing and pretending.
All the gestures and gimmicks.

You showed us that passion has no limits.
You showed us character over currency.
We've been programmed to believe that leadership
leads to assassinated—
when you melanated.
Which has paralyzed so many from taking action.

We've seen the examples,
but you ran toward your purpose
with intention and urgency—
such clarity.

Maybe that's what's so scary—
a man of few words,
but uncomfortable precision.

You are who so many of us are afraid to be.
Your proposal was a movement starter.
I hope one day she says, "Yes,"
and you can invite all of us
to the engagement party.

JAMAAL'S 36 CHAMBERS

ODE TO JAMAAL BOWMAN

East River housing projects
raised a rebel
ready to *Bring Da Ruckus.*

New York is synonymous
with shaking things up
like basketball is synonymous
with the Rucker.

It makes sense
that a lifelong educator
teaches the new rules.

In a nation where
cash rules everything around us,
it feels good to know
you are trying to make sure
the *C.R.E.A.M.* finds us.

For all the years they redlined us,
then gentrified us,
our rage is justified.

So it's comforting to know
you cosign us.

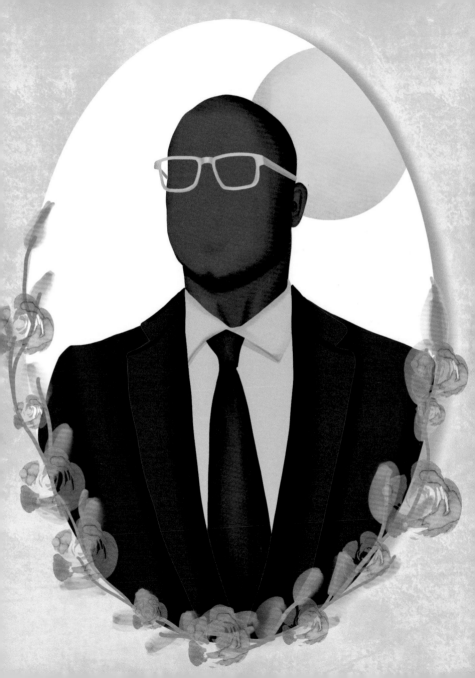

In the midst of all the madness,
you seem to have a *Method, Man.*

You keep putting yourself in position
where they have to listen.
That's power.
That's instigative.
That's inspiring.
That's taking the initiative.

You saw a void
and instead of screaming into it—
you filled it.

Now they can't avoid you.
You put yourself
in the middle of the path.

There's no substitute for authenticity,
and you're teaching a master class.

In the midst of all this separation,
you are finding a way to connect.
You walked into the Capitol and said,
Protect Ya Neck!

KERRY'S BLACK SIDE

ODE TO KERRY JAMES MARSHALL

Birmingham birthed a blank canvas
named Kerry—
who would go on to become a Black billionaire—
chromatically rich.

He watched his father fix
fancy watches,
so he knew taste took time—
and a special set of hands.

A pair that could refine mud,
dignify the dirt,
and snatch the night from the sky—
add some sun, river, and trees
to diversify the value.

Kerry makes Black look rich,
warm and cool—
approachable even.

He grew up near Black Panthers,
so he knew how to give Black claws,
and eyes that pounce.

And every time Kerry laughs,
Thirty-two whites show up—
in grand fashion.

As if they'd been waiting
to be a part of the action.
They don't even beg a pardon.

And it happens often,
because Kerry laughs much—
for varying reasons;
sometimes in humor,
and other times—
in disbelief.

But no matter how often they show up,
Kerry reminds us that Black is rich,
complex, and full of potential.

And if nothing else,
Kerry has taught us
Black on Black is not violent—
it is wealth.

MICHAEL'S MEMORY

ODE TO KILLER MIKE

The son of *Adamsville*.
A product of generational responsibility.
You don't forget where you come from,
so it's clear where you want to go.

It's transparent where your heart is—
with the people.
There are degrees to segregation.
You double majored
in Black and Unity—
and never went back for your master's.

You speak with the fire
of a Southern Baptist pastor,
with the sharpness of a machete.

You speak of history
as if you were present.
The names fall from your mouth
Like old college buddies.

There is a reverence
for those before you
that is so organic
it must be true.

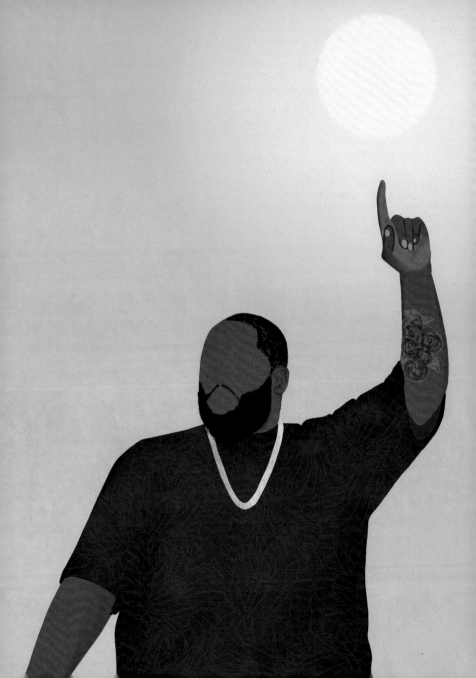

You speak with movement,
not mourning.
Atlanta raised a Killer
who came with a *Trigger Warning*.

What you say
may provoke conversation,
or action,
but what you're doing
is more important than rapping.

As good as your memory is,
you are the constant reminder
that there is power in
Black history, community, and
the Black dollar.

And what I know to be true
is that as good as your memory is
we won't forget you.

THE BOOK OF MARC

ODE TO DR. MARC LAMONT HILL

Who taught you to speak up for yourself and others?

Maybe it was all those convos
with Uncle Bobbie
showing you the power
of self-determination,
and Black self-education.

They can't regulate that.

Who taught you to think for yourself?

Maybe it was the Philly streets
or *Mr. and Mrs. Hill.*
You are the result of love,
wisdom, and redemption.

You are compassion
and culture.
You are academic
and altruistic.

Who taught you that you can be plural?

That you can be plus?

Who taught you not to let them shut you up?

You speak with the passion
of a person who knows
that oppression is a pandemic,
and refuses to treat it
like it's just local.

Who taught you to think global?

You speak like
what happens to the "least" of us
can happen to all of us.

Who taught you to be so inclusive?

What's most impressive
is not what you've learned,
but how you've chosen to use it.

And you chose to do—
that's the best lesson
we can learn from you.

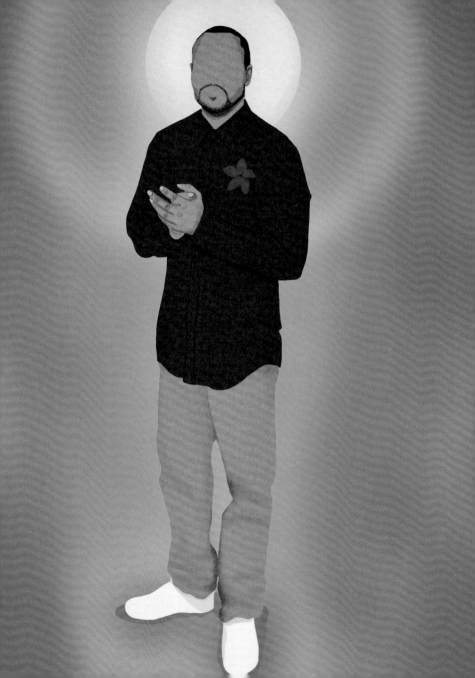

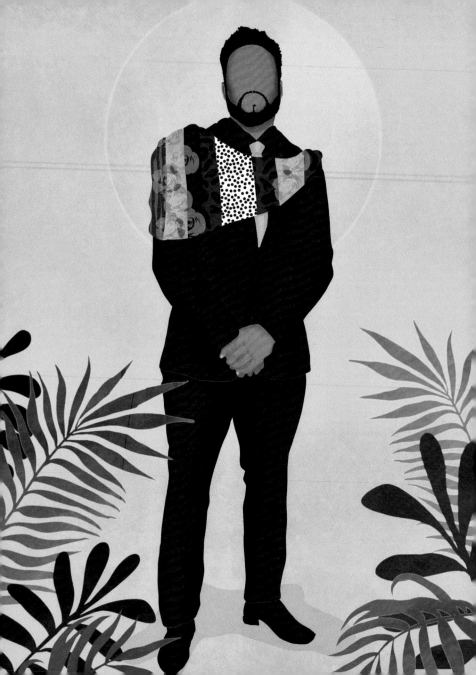

RYAN'S ATTENTION

ODE TO RYAN COOGLER

You know what *Ryan Coogler*'s superpower is?
Diversion.

Every time he opens his mouth
to let that North Oakland accent out
he rarely uses the word "I."

Always directing the attention elsewhere.
Always illuminating someone else
as if he's not a *Marvel*.

It's an audible illusion.
His ability to tell everyone else's story
with pinpoint accuracy,
while leaving himself out of it,
is rare.

We are watching
the manipulation of direction
in real time.

His job doesn't end when the film wraps.
Any question asked
is an opportunity to get the lighting right,
so that we might get a better view
of the full picture—
the unsung heroes.

Making sure we know new names
and put more respect on old ones.
Making films is a contact sport
and Ryan is making sure that they stick.

He's guiding the attention
to the right places
and he makes sure to divert it
to get things back to center.

CHAMPIONS

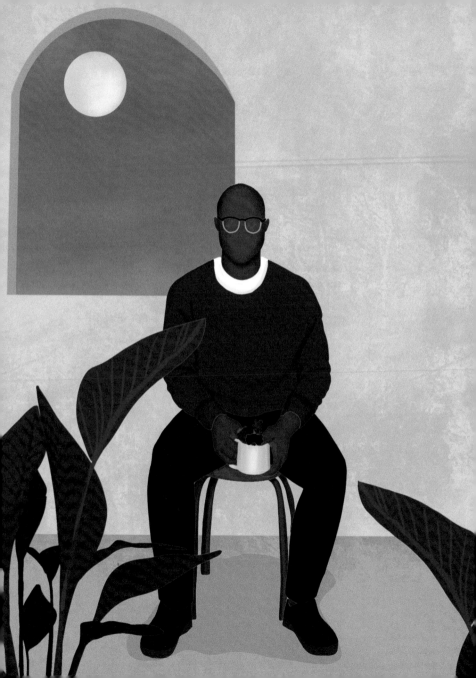

IF LIBERTY CITY COULD TALK

ODE TO BARRY JENKINS

Right there,
in the middle of Liberty Square,
Young Barry
was busy building a time machine
that distinctively resembled a camera—
like those that you make films with.

It was bulky and black
and looked to be made of refurbished material—
everything but the window,
which distinctively resembled a lens—
like those on cameras,
or glasses.
It was spotless and new.

Young Barry went to the past
and noticed what seemed like
a pasture of plush green grass
that led to a humble home
isolated and backlit with a subtle blue.

The sight hugged him with a calm
he hadn't felt before.
All of Liberty Square
seemed to descend on the modest structure.
Looking for a calm of their own.

He decided it was time to visit the future,
because where he's from
people don't make it that far.

For the first time,
his window became faintly opaque,
but he could see that the sun seemed
to shine so intentionally on Liberty Square
that the once-cracked cement pathway
now seemed to be a golden trail.

And there was a bespectacled man
whose face he couldn't quite make out,
but he could see the most genuine smile
ever pronounced on a human face.

He didn't look like he owned the place,
but had found his place.

The yellow glow from the sun
seemed to become more ubiquitous
through his murky window.

He saw the people from Liberty Square
running toward the unidentifiable man
with as much love and excitement
as their bodies could carry.

And the last thing he heard,
before he headed back to the present,
were the people of Liberty Square
exclaiming to the unidentifiable man,
"We are proud of you, Barry!"

THE MYTH OF BIG K.R.I.T.

ODE TO BIG K.R.I.T.

There's a myth
about a man
from Meridian, Mississippi,
who makes music
atop *Mt. Olympus.*

They say there is magic
in his melodies.
It makes many move,
some mad,
and others motivated—
but he remains a mystery.

He refers to himself
as a *King Remembered in Time,*
so they call him "Majesty."

Some say "Master,"
because of how he manipulates
and mixes the mud
to make something that matters.

They say he doesn't believe
in being malicious—
he'd rather *Meditate.*

As Black as midnight.
The moon is his mate.
The stars guide
the type of music he makes.

He uses his emotions as a map
and a mask.
They say he has a Mansa Musa mindset.
His Midas touch is muscle memory.
So you do the math.

When others were playing checkers,
they say he was playing Monopoly.

He's a legend in the making,
So they paint his face on murals.

He grips mics
with all his might.
They say it's because
he's afraid one day
they may turn to mist.

And while he may seem
out his mind,
there's a method to the madness.

He said no one makes it out of *M.I.S.S.I.S.S.I.P.P.I.*
and he'd rather be a myth
than a memory.

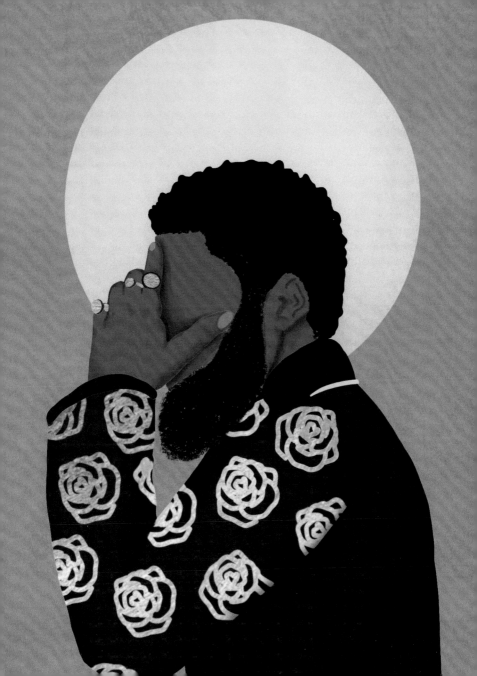

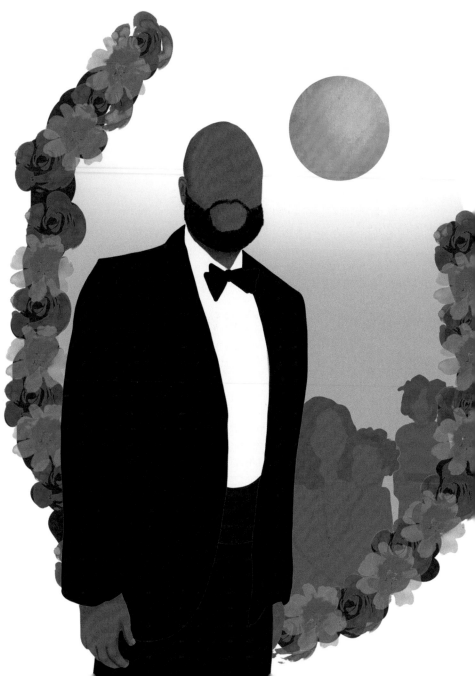

EDMUND'S TRACK RECORD

ODE TO EDMUND GRAHAM III

That Flint, Michigan boy.
It must be something in the water.

Who trained you to run like that?
Who trained you to stay on track like that?
Must have been your father.

Maybe you're just a reflection.
A re-creation.

Who trained you to see obstacles
and clear 'em?
Who trained you to see hurdles
and not fear 'em?
Must have been your mother.

Maybe you are just a result of your training.
A culmination of considerations.

Now look at you—
pupil to professor.
A master of the marathon.
A believer in the baton.

Now watch *Elizabeth*
and *Cassandra* go
because you decided to tell and show.

Ever since their first steps,
you have been their anchor.
Your legacy is based on
how straight you set the record,
and how high you set the standard.

You continue
to attack the curves
and reach for peaks.

Life comes at you fast
and so many of us run out of gas,
but you are teaching lessons
in how to last.

Soon, people will ask your daughters,
"Who trained you to run like that?"
And that is when you can take your victory lap.

ALL HALE, THE CHAMPION

ODE TO ERIC HALE

Have you ever seen a wrestling match?

The ones where
they are thrown against the ropes,
tossed around,
thrown down,
and just genuinely
look to fear for their lives.

But at some point in the match,
they find leverage.
They counter their opponent's move.

The crowd cheers.
They seem to find a second gear.
And all that fear
seems to flush out of them.

And just watching them
make this miraculous comeback
from the grips of uncertainty
makes you feel like
you can do the same.

Eric Hale's students are watching
their favorite wrestler
leap from the top rope
and force a ten count.

Every day he shows up.
Every time he advocates.
Each song he plays
behind his teacher's desk
disguised as a DJ booth.

His special move
is making you believe
you are worth the show;
deserving of the extra mile
and smile.

And any time life throws them against the ropes
and makes them forget
how being a winner felt,
they will remember Mr. Hale
holding up that shiny championship belt.

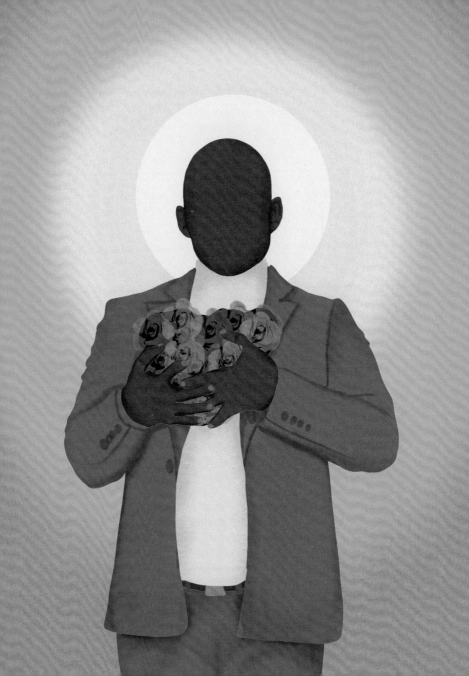

EX-MEN

ODE TO EXCELL HARDY JR.

I wonder what piece of you *Natalya* will have . . .

Maybe your ability to enterprise.
To see the world as building blocks
and be architect,
carpenter,
and foreman.

The ability to turn foresight
into fortune.

I wonder what piece of you *Leila* will have . . .

Maybe your ability to be taken lightly
and seriously simultaneously.
That's an impressive balancing act
that requires the precision
of a tightrope walker.
A fire-breathing war stopper.

I wonder what piece of you *Lil' Ex* will have . . .

Maybe your ability to embody your name.
Like, whenever the moment calls for it,
he can summon the power of his forefathers
and *rise* to the occasion,

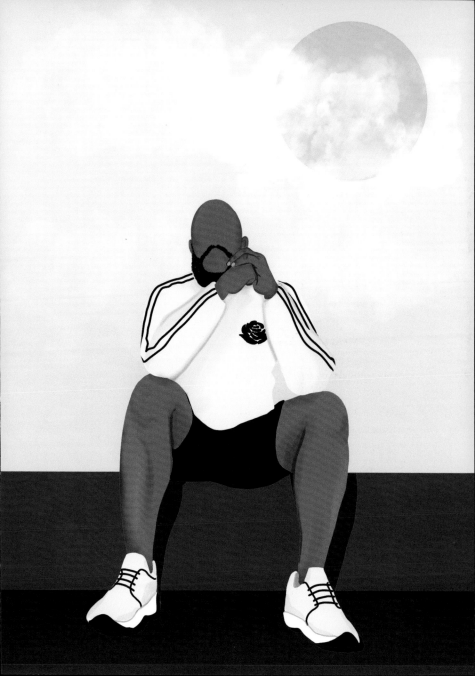

surpass the expectations,
only know *elevations*—
even in his valleys.

All I do know
is that they will all benefit
from your abilities—
passed on like an assist,
or a family heirloom.

It's up to you to show them
how to use their superpowers wisely.
You are their professor, Ex.
May they continue to learn from the best.

THE WALLS OF JERICHO
ODE TO JERICHO BROWN

Where I'm from,
there are duplexes.
They either sit on top of each other,
or side by side.
They make good use of dense areas.
I grew up in one,
so I am quite familiar.

Jericho Brown is a *duplex*
of his own invention,
and *Tradition*.

He houses multiple things
and makes good use of dense areas.
Black and man—
Man and poet—
Poet and smiler.

Jericho smiles when he talks.
Even when it is *juxtaposed*.
Even if the subject is worthy
of tears more than smiles.

Maybe that is an act of rebellion,
an intentional metaphor.

A *repeated* practice
so you get the point,
but don't get comfortable.

Jericho is *sonnet* and *soliloquy.*
He has created these confines
just to make good use
of how dense this life can be—
as Black and man—
man and poet—
poet and architect.

Jericho has built himself
a beautiful home
inside those poems
with enough space for multiple things.

The most intriguing truth about duplexes is
they have separate points of entry,
but are always connected.

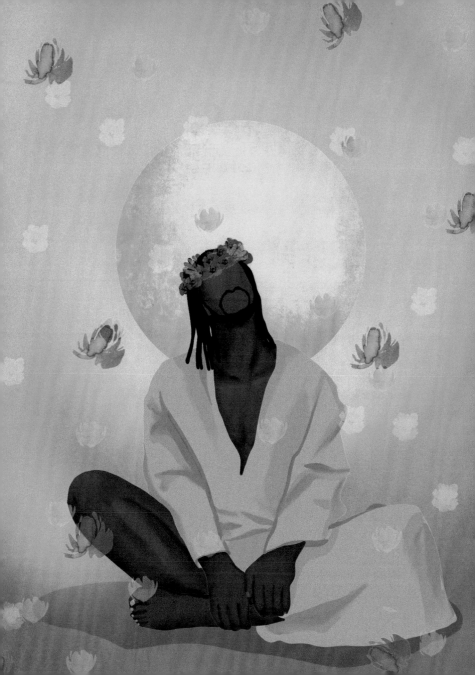

KING JAMES VERSION

ODE TO LEBRON JAMES

When my grandchildren ask
what I remember,
I'm going to say,
"I witnessed *King James*
leap into the air,
pump his fist,
and high-five the love of his life
as they watched their heirs
come into their own.

"I saw him turn the backyard of his home
into his daughter's very own
tea party;
as he realized in real time
that she was becoming the biggest star of the family."

I'll tell them
that he created a blueprint out of thin air.

I'll let them know
he practiced being a father
as much as he practiced free throws.

I'll tell them that his biggest fans
didn't need an autograph.

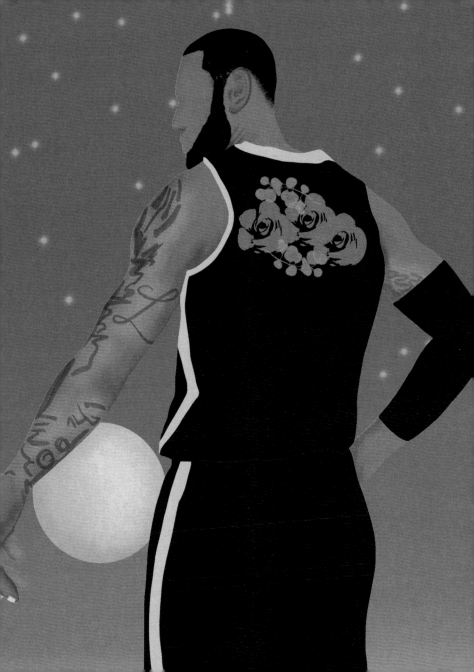

They just wanted him to learn a new dance.
They just wanted to look over
and see him in the stands.

I'll tell them I witnessed
a larger-than-life figure
become a mortal man
at the hands of his greatest accomplishments.

I'll tell them
we celebrated his wins,
but he never forgot
who inspired him to accomplish them.

I'll tell them
I saw the focus in his eyes
whenever playoffs came around,
but it paled in comparison
to the joy in his smile
whenever his children were around.

He showed us
never giving up on your team started at home.

A world champion father.
I won't remember every stat,
but I'll never forget that.

TRISTAN'S BARBERSHOP

ODE TO TRISTAN WALKER

There is a cultural town hall
that erupts in Black barbershops
and is incomparable.

On any given day
it can serve as the *inspiration*
to be our highest self.

Or help us succumb
to our deepest ignorance,
but it is where conversation
meets curation.

And *Tristan Walker* had the courage
to bring the Black barbershop to the world
in a package that would
make them respect the conversation.

And in this barbershop,
Tristan is the barber
who is the most technical,
always talking about enterprising,
and community *wellness*.

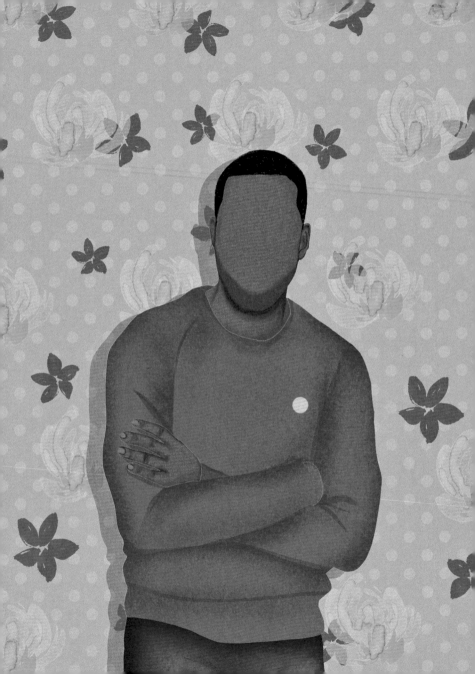

And has the highest client *loyalty*
because he always talks
to you like he knows you.
Remembers your tendencies
and stories.
Listens without *judgment*—
just understanding.

There's something about a fresh haircut
that makes you feel capable.
And at the core,
that is what Tristan is creating—
capability.
That's the product.

When you feel and look good,
you can do anything.

Tristan is selling bravery—
and the most important customers
in his metaphorical barbershop
are *August* and *Avery*.

DREAMERS

MORE CHANCES

ODE TO CHANCE THE RAPPER

It took *14,400 Minutes*
for you to carve out your space,
but your whole career
has been a love letter to your birthplace.

I just hope you and Windy
become *Eternal* pen pals.
May your reign last awhile
because even when *Acid Rain* falls in piles
you make it feel like *Everybody's Something*.

Everybody's favorite cousin,
but the real *Blessing*
is how you treat *Family*.
Kirsten, *Kensli*, and *Marli*
get all your *Cocoa Butter Kisses*;
double as Northern Stars
when you venture too far
and feel *Lost*.

You placed *Taylor*
on your *Broad Shoulders*
so the world can see him
as you do—
while *Mr. Bennett* smiles at both of you.

What a feeling,
collective winning.
Waving *Hey Ma* to *Mrs. Bennett*.

What a *Miracle*
to have the taste
of Granny's *Sunday Candy*
still on your tongue—
that's why the bar's so sweet.

Baptized in the chilly waters
of Lake Michigan.
Branded by the bumpy Southside streets.

You are the *Rememory*
of all we've forgot.
How Great the feeling
when love is *All We Got*.

Great examples
usually have great examples.
You are a reflection
of that sentiment.

May your *Big Day*
become a big life.

May your purpose
power
lights dimly lit.

May the multiplication
of your energy
be massive.

We need more Chances.

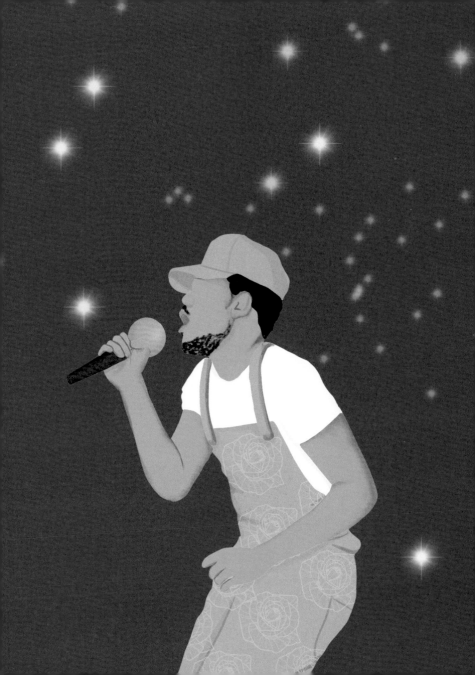

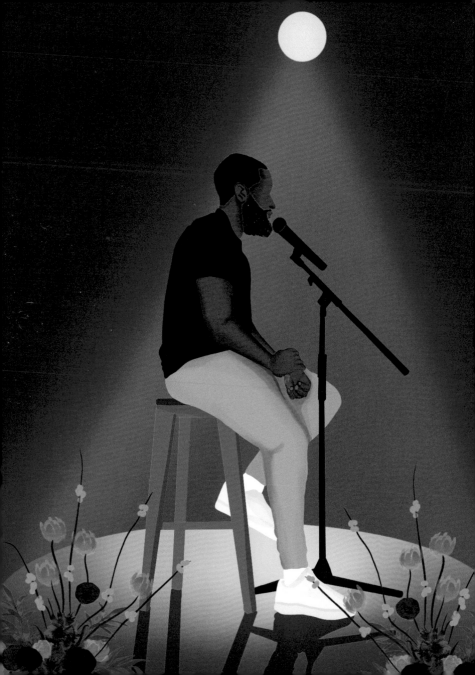

FLOWERS FOR THE FLORIST

ODE TO HAROLD GREEN III

Look what you did, flower man.
With belief grander than a mustard seed,
look at this garden you grew.
A botanical bliss.

When they ask what's your secret
tell them,
putting the ground in your grips,
giving the soil a kiss,

and granting grace for growth
to all the things
that are normally dismissed—
including dreams.

That's a gift.
You are a gift.

To not let love die.
To get on your knees
and fertilize the dirt
with your tears.

To believe
even when it hurt.
To take up landscaping

as an occupation,
because land is a form of power
and beauty—
which is a necessary resource.

And you know
if you could join the two,
out-of-reach ideas
could bloom through.

This beautiful land
you have curated
is a reminder
of an ancient truth—

that flowers
still grow toward the sun.
You are the light.

Don't you ever
let this world
take that from you.

Even when this world
is absent of you.
You will shine on.

These flowers you planted
will grow on.
Your garden is eternal.
Live in that truth.

HEBRU'S CANVAS

ODE TO HEBRU BRANTLEY

Somewhere in a perpendicular universe,
there is a crossroad on the horizon—
a liberation at dusk;
littered with goggles and stardust.

But the vision is clear.
You've shown us
that we are not only here,
but we exist eons from now.

That's power.
That's prophecy.
In your eyes,
our excellence and presence is certain—
not probably.

In that perpendicular universe,
Jayden is giving *Flyboy* coordinates,
and a crash course
on how diligent his father is.

A creator
who never asked to be a deity,
but helped his people experience art spiritually.

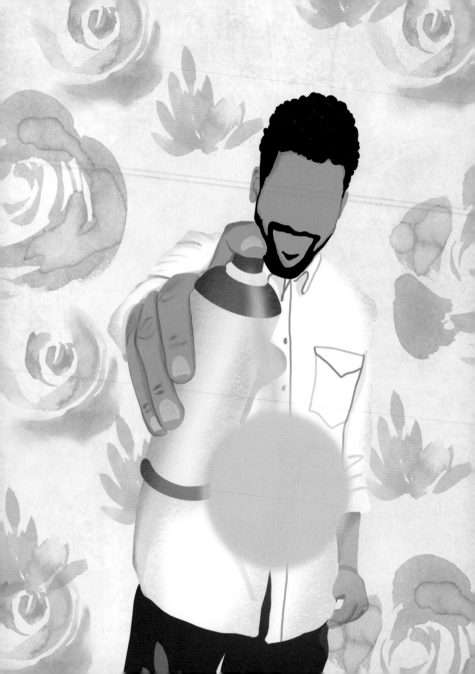

He sculpts their soul
and paints their prayers.

On the opposite side
of that perpendicular universe,
Hero is playing patty-cake
with *Lil Mama*.

As they smile like spitting images—
the symmetry of a fine crystal.
Some parents pray for better days,
but you painted the picture.

Some of us hope for change,
but with every stroke,
you transform a victim
to victor.

You show us what forever is for
through *Nevermore*.

Basquiat's Bastard—
The Son of SAMO—
shows us he'll never be Sambo.

And one day,
those perpendicular universes will intersect
and it will be your best creation yet.

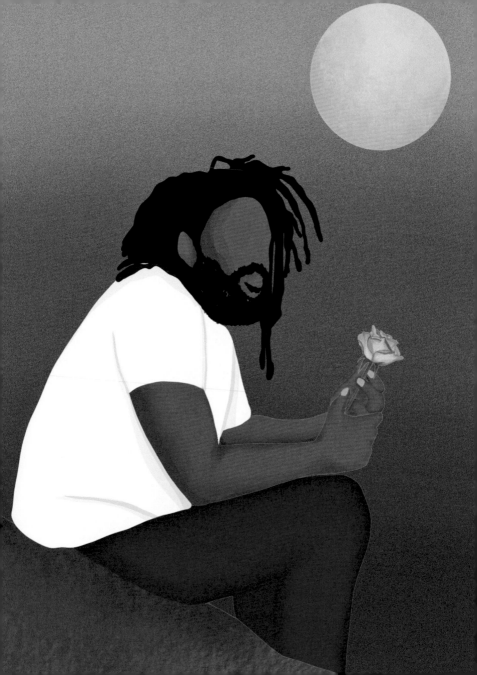

JASON IN THE MIDDLE

ODE TO JASON REYNOLDS

It's so easy to listen
to you speak.
It's as if you have found
insight and peace
from giving us pieces of you.

You aren't on a journey to be right.
You're just not scared to try.
If we could all be *As Brave As You*.

Baring your soul
through bundles of books
is not *For Every One*,
but what we can learn from your ascent
is that even though
it's a *Long Way Down*,
there's nothing wrong with starting all over.

The climb makes us new
each time;
a little less scared of heights,
and even more attentive of our steps.

You write for *The Boy in the Black Suit*
in hopes that mourning
does not morph into regret.

For the *All American Boys*
of African descent,
to remind them they are not defect.

You are portraying normalcy
for those *Stamped* unworthy.
I wonder if you knew
you would be creating
a covert revolution
through your writing.

Molding the minds
of those in the middle.
To carve out space for them
with intention.

Not telling them who they are,
or what to say,
but just reminding them,
and all of us,
that when you meet a crossroad—
You *Look Both Ways*.

KEV'S BALANCE

ODE TO KEVIN FREDERICKS

You can always identify a man
who has perfected the art of balance
just from a few glances.
You can see center in their pupils.

You found center in family.
Your foundation is apparent.
You're a household name.
Especially in the one that matters most—
your own.

No stage names at home;
they call you by the only one that matters—
your own.

A one-man show,
but you keep expanding
the dimension of your stage
so everyone can come along.

Look at the job your parents did:

Military precision and discipline
from your father.
Work ethic and creativity
from your mother.

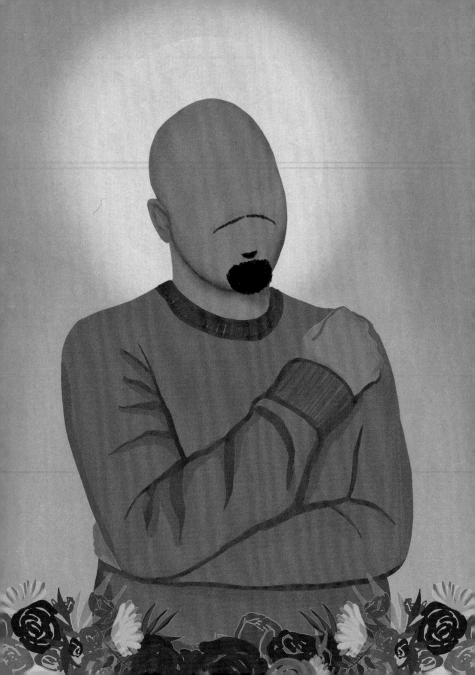

You inherited vision.
Wow, we see the world
through your eyes.

You help us live out loud
from LOLs.

You help us escape reality
on a daily basis
while you deal
with the constant pressure
of creating.

I know you can't shut off that motor,
so I hope you've mastered breathing—
as you have balance.

The same way you've shown us
the beauty in duality—
the *Righteous and Ratchet*.

You have the ability to create joy
in the midst
of a three-minute clip.

To control hearts and time
is a superpower.
Thank you for inviting us
to your *Love Hour*.

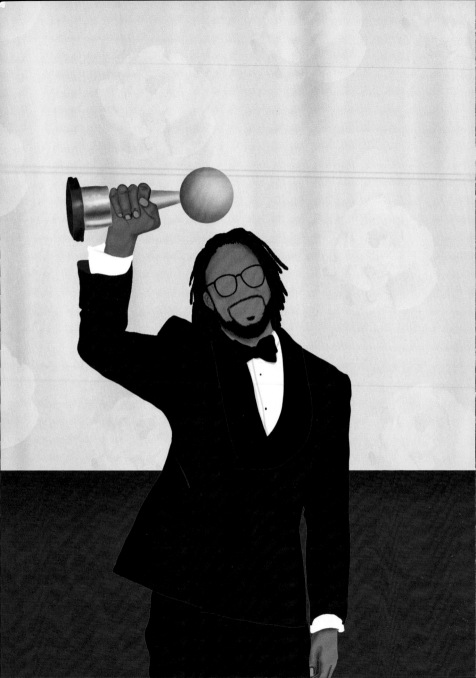

MATTHEW, THE NORMALIZER

ODE TO MATTHEW CHERRY

What you choose to do
with the light given to you
speaks volumes
and you are at sixteen-inch subwoofer levels.

We hear your light
from miles away.
Actions are so loud
and we see what you have to say.

You make sure people are visible
without putting yourself in the way,
while putting in all the hard work
to make it possible.

You are worthy of ovation
but always seem to be
the one giving it.

The receiver
turned quarterback—
the way you put things in motion.

This is for all those nights
you were working
and hoping.
Thank you
for putting it all in focus.

A king on his proper throne—
The director's chair.
Under the *Crown Act*,
over the *Monkeypaw*.

The world watched *Hair Love*,
but Black girls saw themselves
through love's lens.

The world saw you win,
but Black fathers saw themselves
and knew it was okay to try—
to love, to fail,
and do it over and often.

You normalized a relationship
we all know exists,
but is treated as myth.
You have lived up to your name, *Matthew*.
You are truly the gift.

THE BLACK MONK

ODE TO THEASTER GATES

I believe that geniuses
can apply the specific skill sets of their discipline
to anything
and produce noteworthy results.

There is genius
in the way he
has created a potter's wheel under Chicago.

He constantly molds and shifts,
shifts and spins
the city to make new from old.
All while producing enough heat
to turn Cook County into a kiln.

He turns *Tarred Vessels*
into fine art.
Those once disregarded
and frowned upon
are now gazed at
and loved on.

There is a *Civil Tapestry*
in the way he connects
the micro to macro,
minority to majority.
He's created a *Grand Crossing*.

If the infrastructure is failing,
you must *Rebuild the Foundation*
with patience.

You must create a *Listening House*
before you start speaking.

An Archive House
before you start throwing things out.
There is history here.
We are living documentaries,
and he has built
the *Black Cinema House*.

There is genius in the way
he saves discarded materials
from meeting their demise.

So maybe his biggest project
is keeping his people alive.

TYLER'S TESTIMONY

ODE TO TYLER PERRY

On the outskirts
of the American Dream
is a subset
of desires, plans, and aspirations
called the *African American Dream*.

In the middle of this idea
stands a giant
who once believed himself an architect,
but now builds bridges
in efforts to help others cross.

He knows that absolution
does not mean memory loss,
but it can mean peace.

He is filled with as many stories
as twenty New Orleans streets.
He believes in victory
more than he does defeat.

He knows that a loss
just makes way for the win.
A master gardener
who knows *here, we grow again*.

He shows us
that even when you come from
a *House of Payne*
there is still joy
left for you to claim.

The boy who made his mother cry—
from pride,
became the man to build bridges,
plant seeds, and father *Aman*.
What an emotional ride.

Such a scenic route
on a road paved with gratitude,
perseverance, and remembrance.

In a vessel fueled by
Faith, *family*, and *forgiveness*.

Through his journey,
we all have witnessed
that *Higher Is Waiting*.

And in the middle of this subset,
he has shown us
that this is the *place where even dreams believe*.

GUARDIANS

CHARLES AND THE KENTUCKY TREE

ODE TO CHARLES BOOKER

What happens
when strange fruit
drops from Kentucky trees?

They sprinkle seeds.

Charles Booker grew
from the mix
of blood, tears,
and the seeds of strange fruit
in Kentucky soil.

The prospering of those
who were never meant to be
is a sight to see.

But Charles breathes
the air of champions.
The birthplace of *Ali*,
same place that birthed
Prestyn, *Kaylin*, and *Justyce*.

So please know
Charles will fight for Kentucky
until they pull him out the ring.

You can hear him *holler*
from the *West End*
to *Butcher Hollow.*

There is a commonality
between people who feel forgotten—
it's the desire to be seen,
a craving to be heard.

And maybe that's what
makes Charles special.
He knows what it's like
to be the invisible man.

Maybe that's the tie that binds.
Charles knows how a whisper
transforms into a roar.
It's hard to ignore.

Charles knows the battle is different
when you come from the soil
that you're fighting for.

Kentucky didn't know
that strange fruit
would drop seeds
that would grow into you.

FATHER FLASH
ODE TO DWYANE WADE

Who protects the little boys
who are little girls at heart?

Who protects the little girls
who are little boys at heart?

Who loves those that choose
to live without labels?

When in positions of power,
do we project our fears
or protect their hearts?

Look how you lead
with a listening ear.
This is the best alley-oop you've ever thrown.

Our parents are our first
lessons in love.

How can we expect children to feel accepted
when rejection starts at home?

How can we not expect them to be light
when love is all they've ever known?

Father time
has nothing on *Father Flash*.

This journey didn't happen overnight.
This is the result of blocking out outside noise
and having insight.

This is putting your foot down
and making people respect pronouns.

This is not only allyship.
This is being an advocate.

This is being a parent,
not a provider of pain.

This is making way for rainbows,
while removing the rain.

This is making a *Way*
of Wade

So many confuse sexuality
for character—
gender for morality.
This is you showing they are not the same.

You never retire from being a father;
it's an ongoing process.
And as long as you lead with love,
you know you tried your best.

You are changing the world—
for the ones you are sending into it.
It's inspiring to see you do more
and not less.

POP'S CHOREOGRAPHY

ODE TO HAROLD GREEN JR.

I learned so much about joy
from watching you dance.

The way you defied emotional gravity.
The way you pushed problems
into the sky's abyss
with each hand you flung in the air
with knifelike precision.

All excuses separated
with each surprise split
and the worry you shook off
with each sway of the hips.

And that thunderous clap
from the callused hands
of a man who worked manual
and mental labor
seemed like a manual reset.

To watch you
control a dance floor,
when other things
seemed out of your hardened hands,
taught me
there are more reasons
worth holding on for.

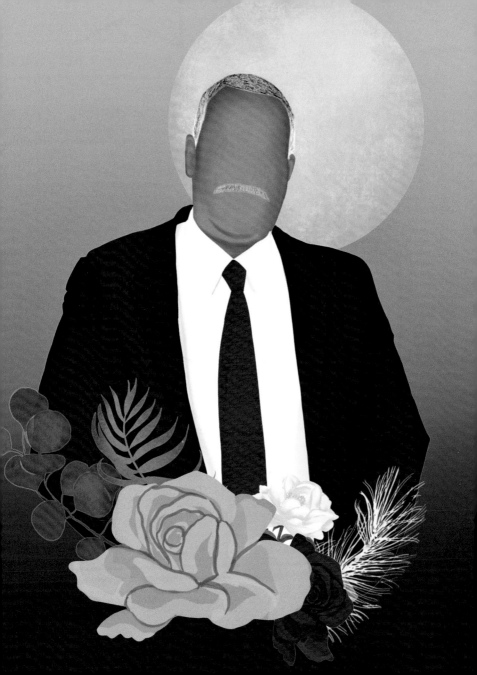

The way the crowd
would create space for you.
The way they watched
in awe and admiration.

A Black man performing
in the key of liberation.
To watch you be free.

You taught me
to push through,
split open,
shimmy,
and use my hands
to reset the room.

As time goes on,
the dance downsizes,
quite naturally,
but your body
still remembers.

And so do I.

Your choreography taught me
no matter what life takes from you
always create space for joy.

AN ACT OF DISCIPLINE

ODE TO MAHERSHALA ALI

Discipline is enticing
in a way that is reactionary—
physically.

Not physically imposed discipline.
The type of discipline
that doesn't have to touch you
for you to know that it is omnipresent.

Not like God,
because this type of discipline
does not desire divine declarations.

The type of discipline
that doesn't have to denote
when it has arrived,
because you feel it
creeping up your back
like arachnophobia.

Making you fix your posture
like a *Blade* ever so gently
poking your spine.

Discipline has a presence
that makes senselessness absent.

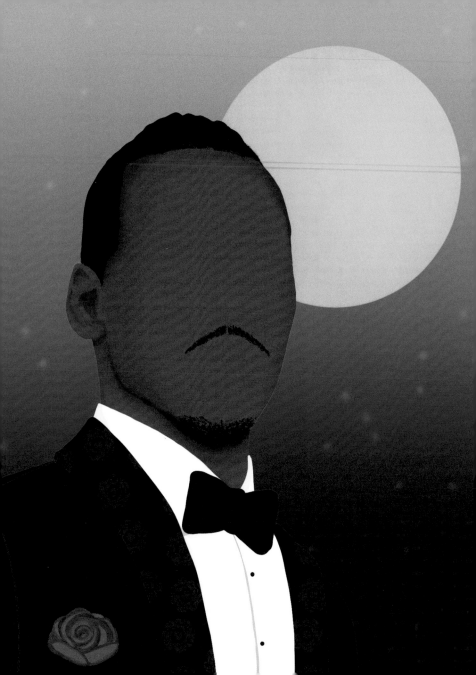

There is no replication of discipline,
only repetition.

Discipline is practiced in the dark
just to create light.

Discipline interrogates the room in silence
like a *True Detective*.

Discipline doesn't make it look easy,
it makes it look appealing.
Discipline can make ~~eras~~ errors,
but is timeless.

Discipline can demolish walls
and set boundaries.

If success is a home
then discipline is the key.
If discipline is personified
then he is *Mahershala Ali*.

FINDING ORLANDO
ODE TO ORLANDO COOPER

There is a certain power in laughter
and those who provide it.
There is purpose
in the type of comfort you provide.

Your presence
puts others at ease.
You feel like home,
or at the very least
an escape.

Makayla is your mirror.
You are pom-pom
and protector.
Support
and satire.

But underneath it all
is an endless reservoir
of empathy.

Creating joy
is your form of philanthropy.
And you give—
often and plenty.
I have been witness
and recipient.

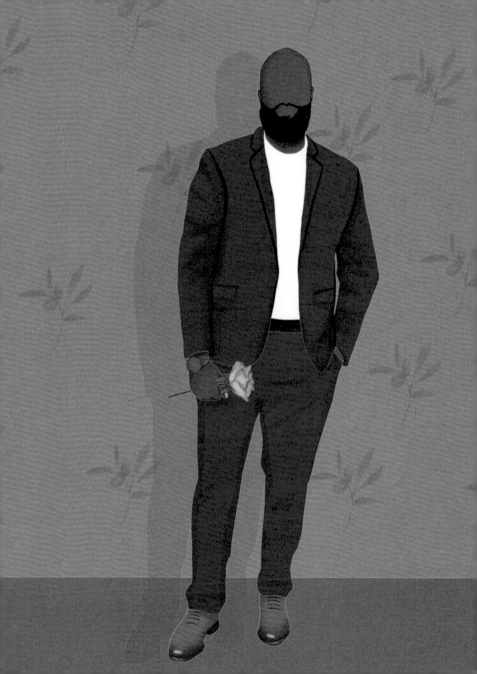

How assuring to know
whenever I feel lost—
I can find you.

How beautiful it is
to know I'm not alone in that quest.
You are a light tower.
This world has never broken your posture
or dimmed your light.

The son of a *Pearl*.
You shine
and remain tall
to make it easy for us all
to find you.

What a sacrifice.
What a legacy.
What a gift—
knowing that this life is going
to treat you as well as you have treated it.

IN THE FOOTSTEPS OF OTIS

ODE TO REV. DR. OTIS MOSS III

The Holy Trinity:
the *Grandfather*,
the *Father*,
the *Son*.

The harvest of a sharecropper
who planted seeds
that grew into reverends and doctors.

The way you make connections
is a direct reflection
of your appreciation
for inspired living.

We all benefit from those who pursue better,
and you are a witness and descendant.
You are the sample of a sample.
Each use adds another layer
in the pursuit of better.

You operate with a level of respect for the past
that makes all of us look back
with pride and passion.

You orate in the future tense.
So sure of the unseen.

You speak as if
faith is a part of the fabric
that creates forward motion—
aerodynamic optimism—
panoramic realism.

How elated *Elijah* and *Makayla* must be
for love and excellence to be
the family hand-me-down,
and it always fits.

What a gift.

You have followed the lead
of those before you
and created a path for those to come.
That's a timeless blueprint.

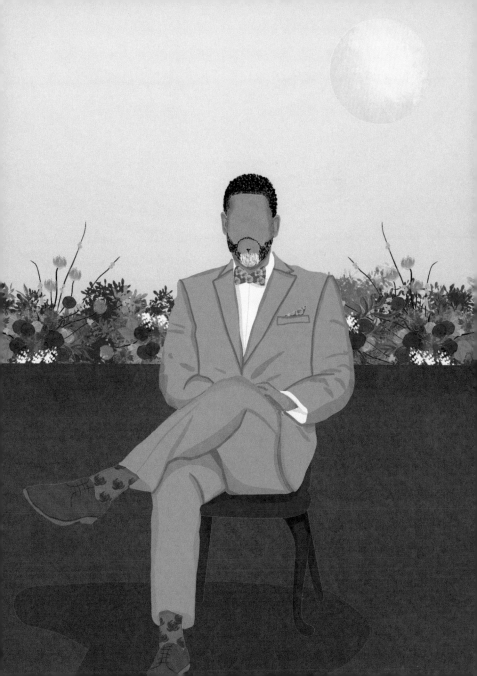

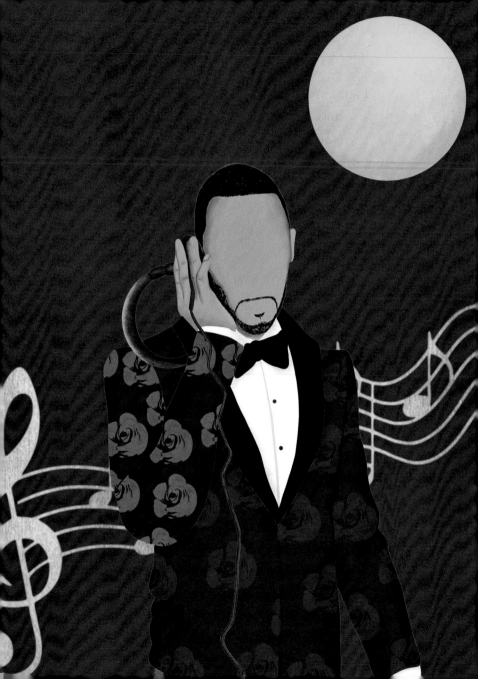

SWIZZ BEATZ VERZUZ KASSEEM DEAN
ODE TO SWIZZ BEATZ

<u>*Swizz Beatz the Monster!*</u>
The way he rips apart drums,
chops up beats,
then found a seat
so he could dominate *Harvard.*

Never one to be boxed in
Terrorize a *zone,*
then it's *On to the Next One.*

He covers every inch.
His pressure is *Full Surface.*

A man on a mission
to turn creatives
into champions
and asks for *No Commission.*

With a sonic signature
that secured his place in hip-hop history—
without having to ask permission.

The *South Bronx Speakerbox*
made the world listen.

Kasseem Dean the Father
Has found peace in the journey
and brought love to the light
in the *Keys* of life.

He would build the pyramids
for *Egypt*
to show *Prince* how to be a king.

You are the *Genesis*
and *Kasseem Jr.* is the continuum.

All that you build presently
is the future that *Nicole* will hold—
what an image.

The ones that inspire you
end up being the ones benefiting.

Your legacy is full circle.
Your love is so inclusive.
You dream like a man
who knows the importance
of leaving no one behind.

You continue to bring the best out of yourself.
You competing against yourself
is the best *Verzuz* of all time.

TOBE'S SABBATH
ODE TO TOBE NWIGWE

I can still feel the energy
from Thalia Hall—
my first time seeing you live;
emotion fell from my eyes.

I saw myself on stage.
Years of Sundays—
what a payoff.

May you always *Prosper*
for going *Against the Grain*
and making *Purpose Popular*.

When they say yours,
they gotta say your wife's name,
what an *Ode to Fat*.

She probably knows
your verses better than you.
She probably saw
your *Growth* before you.

You've given *Caged Birds* wings;
shown them they can *Shine*, too.

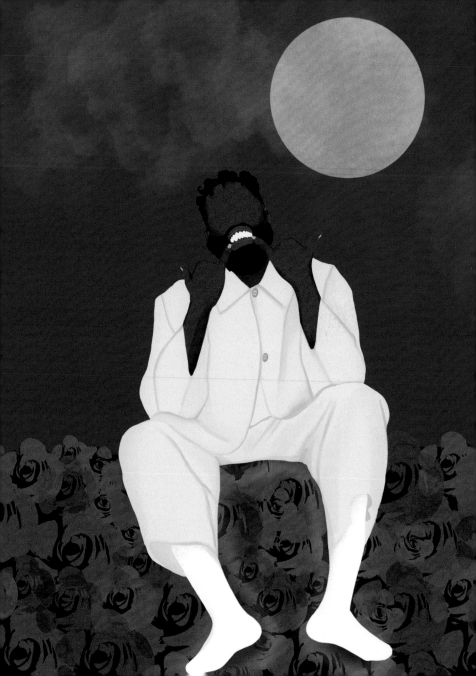

What a feeling
to look love in the eyes
and say,
I Choose You.

May your blessing be *Bountiful.*
May *Sage* and *Ivory*
always know they're beautiful.

May you always know success
and *What It's For.*

Even after *100 K*s
all you need is one homer
to get on the board.

And look at the score,
you winning with your *Day Ones*,
doing what comes natural—
Tabernacle.

You went from linebacker
to *Zen Master*,
but still ready to *Murder*
any beat *Nell* cook up.

With the right *Spice*,
that's a *Heat Rock*.
Leave your chest burning
even after the beat stop.

We saw the work ethic
wasn't wavering,
so now the whole world is *Jockin'*.

Even when the smooth sailing gets *Wavy*,
you're still locked in.

I wrote this on a Sunday,
because it feels like hope.
I just want you to know
you helped us look in the mirror
and say,
I'm Dope.

HUMANITARIANS

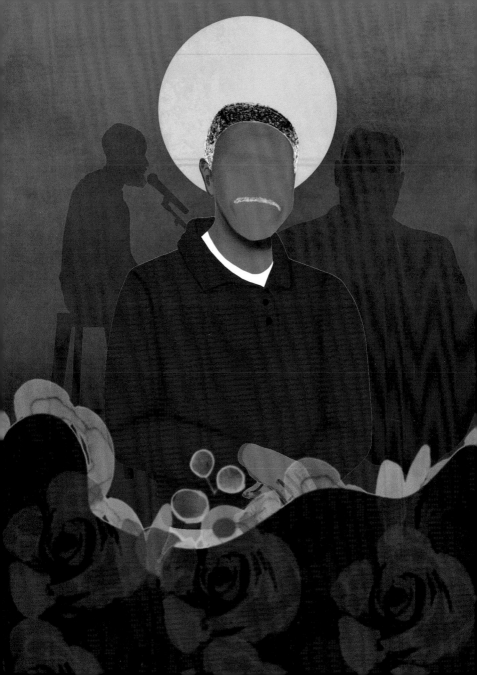

MR. GREEN'S NEIGHBORHOOD

ODE TO HAROLD GREEN SR.

The embodiment
of a helping hand.
I never saw an empty belly
around you—
or an empty oven.

Always a full house.
One of the best smiles
I've ever seen
in a human mouth.

A work ethic
that knocked every wrinkle out.
I can still feel
the bristles of your beard
on my face.

You exemplify
that a handshake
isn't enough.

There is love in that embrace.

You put your heart in that gumbo
and your foot in that bread pudding.
There's no telling
how many people
have a piece of you.

There must be magic
in that roux.
A voodoo
that only New Orleans
can teach you.

The way you elevated the spirits
of those living on *Lowe*
was a show in itself.

The way they lined up
just to get a taste
of your heart
was a sign
of appreciation and respect.

You demonstrate
what proper pride looks like.
When you have enough for yourself,
it spills over into others.
And you have a surplus.

I learned the power
of giving away
what you have plenty of.
Thank you
for sharing your heart with us.

BY THE GRACE OF GATES

ODE TO DR. HENRY LOUIS GATES JR.

Grace is a rare concept
that can be quantified
and made tangible,
even personified.

There's something in your posture
that brought me to this conclusion.
The great unifier.
The magnificent arborist.

Just look at all the *Roots*
you've nursed back to life
with such joy and care.

For every person
that you have connected
to their past,
reassembled their limbs,
and made whole again,
you have committed an act of grace—
quantifiable.

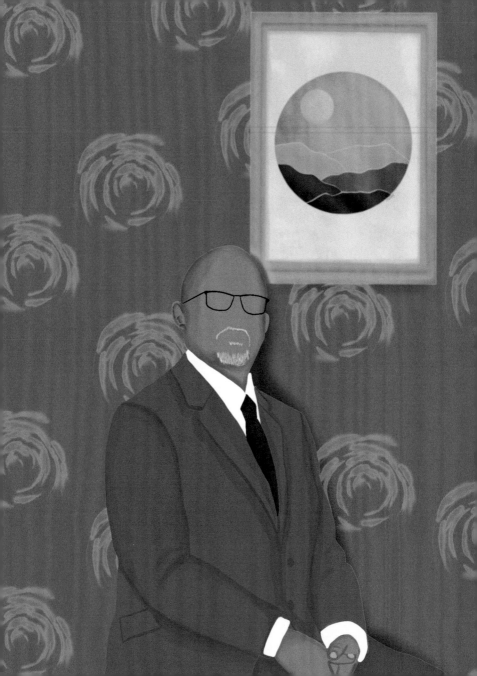

Every time that person
could reach out and touch
a piece of their history,
embrace a different kind
of family reunion,
that was you making grace palpable—
tangible.

And every time you pushed
the mirror in front of America
to remind them
that We are just as much
a part of this family as anyone,
you were the grace—
personified.

When I say your name
I must say it in full,
Henry Louis Gates Jr.

You can't *Skip* one syllable
of a man committed
to helping us see our full selves.

JOHN'S LESSON
ODE TO JOHN LEGEND

What a privilege
to be alive in a time
when you decided
to share your art.

I remember vividly
riding in my dad's car
watching him sing Stevie
with all his heart.

It was the *Prelude*
to how I would view you.
Stevie was his teacher.
In turn,
you have given me
so many lessons in love.

You convinced me
that *Ordinary People*
can have extraordinary powers.

I learned that love
can lift us *So High*
that we forget
our fear of heights.

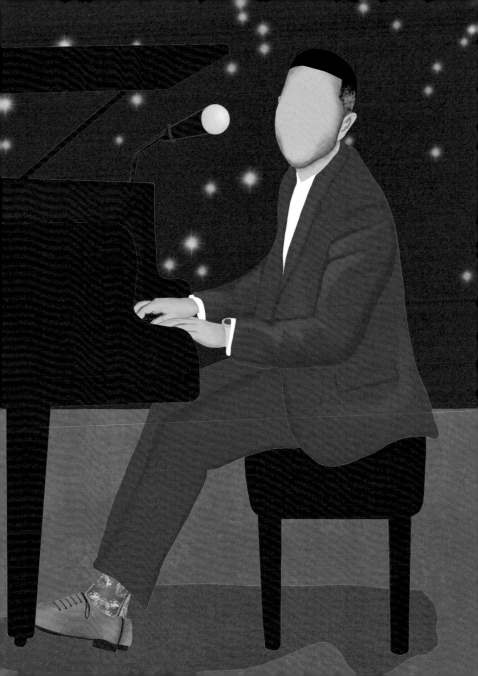

When we stand on love,
we are skyscrapers—
tall towers.

And even when we fall,
it's in love.

And we say,
Let's Get Lifted Again.

I've listened to you on repeat
in autumn
while watching
the leaves escape the trees.

And I had an epiphany
that *I Can Change*, too.

In your professions,
I've found *Refuge.*
In your lesson,
I've found light
and knew it would be *Alright.*

Your lyrics are tattoos
the way they *Stay with You.*

You demonstrated to me
that grace is everlasting,
even for those who *Used to Love U.*

It *Don't Have to Change*,
even with a *Bigger Love*,
the intention remains the same.

May your love
give *Luna* and *Miles* wings.
So they can always *Live It Up*.

Your music taught me
how to dance with my wife,
but *She Don't Have to Know*.

But I hope you always know
that you did more than enough,
because even when
your classes are done
the best lesson I learned
is that on a long list
of extraordinary powers—
Love is *Number One*.

KEHINDE'S REPUBLIC

ODE TO KEHINDE WILEY

There is a declaration that occurs in Black culture
while playing a spirited game of dominoes.
When the foreseen winner slams their last piece down,
they exclaim, "*Bones!*"
in a booming victorious voice.

Kehinde Wiley is playing with bones.
He is an excavator and renovator—
simultaneously.

Digging up artifacts,
dusting off the *Old Masters*,
and creating shiny new *icons*
out of the antique anatomy
he wasn't supposed to inherit.

He has found a way to place
flesh on those bones
without perpetuating fetish.

He has taken bloodstained streets
and created bold stained glass.

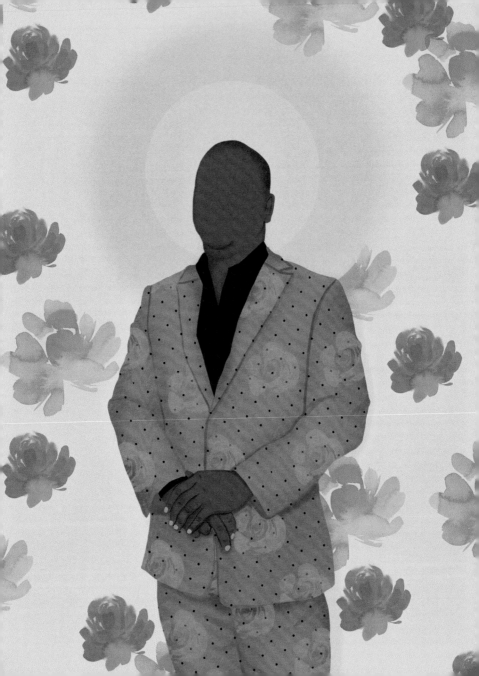

Every time he turns Black into a masterpiece
hung on the walls of institutions
once blind to our humanity,
I imagine him whispering,
"*Bones!*"
under his breath—
with that victorious smile he wears.

Every time his work hits the wall,
those old bones get rattled
and spread,
making room for new bodies.

There's also something fascinating that happens
when you place dominoes in a row.
When one falls
it has an effect on the rest.

When *Rumors of War* start,
that first whisper
can be the wind
that blows the first domino down—
with many others to follow.

Defeat is a verb not endured alone.

I just imagine as Kehinde
stood in the middle of *Richmond*
watching those dominoes fall,
he whispered, "*Bones!*"

THE INCLUSION OF MR. BROADUS

ODE TO KYLAR BROADUS

Courage is a numbers game—
the more people you are fighting for,
the scarier it can be.

If your fear overwhelms you
in a fight for one,
then the pressure is less paralyzing.

But when your bravery
is bound to the ghosts of generations past,
and the hopes of lives not lived,
then courage becomes a currency.

And look how you choose to spend your courage.
All those expenses
can get expensive,
but you continue to foot the bill.

Maybe it's all that confidence
that your parents instilled
that allowed you to be so clear
on who you are
from the inside out.

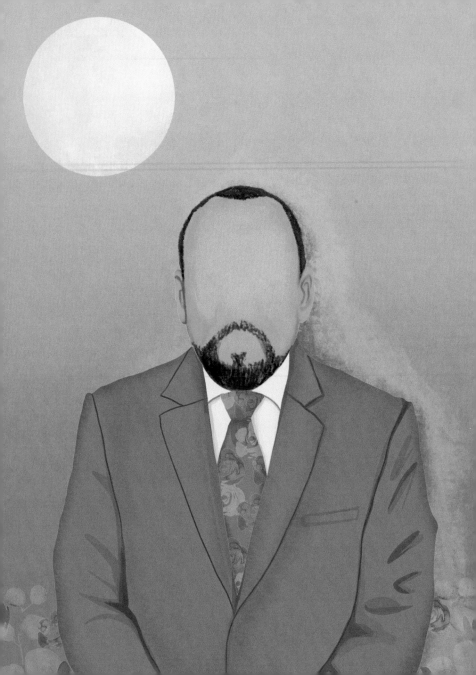

Maybe all that love they gave you
pushed out the doubt
and made room for that courage.

Their advocacy
built a repository in you
with more depth than you knew.

So every time you think that
courage is running low,
you reach deep down
just to find a little more
lying around.

And every time you spend it,
you realize it was worth the splurge.
I'm so glad you fought off any urge
to be frugal.

I hope you never regret it,
because the way you have spent your courage
you deserve so much credit.

PHARRELL'S LONGEVITY

ODE TO PHARRELL WILLIAMS

We are all
In Search Of clarity
And you've shown us
what it meant to be *Human.*

Forever evolving,
an eternal student.
Learning from the past
and studying for the future.

You speak as if you have
conversation with the constellations.
Maybe that's why
your journey
has been on a *Star Trak.*

You possess the poise
of a man who's had the chance
to reflect.

Skateboard P,
And the "P" stands for "Present"—
a gift
and of the moment.

Ageless
and timeless.
Embracing your truth
must be the fountain of youth.

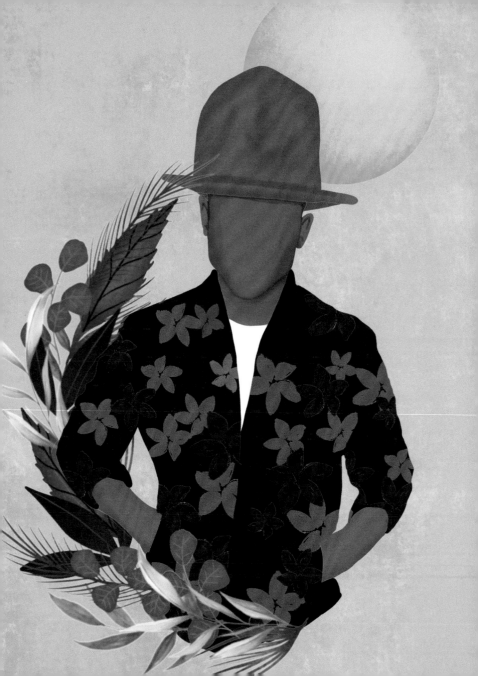

Word to *Helen*, *Rocket*,
and the triplets, too.
Virginia is for lovers
so Virginia is you.

The year is 2002,
every lunch table in America
is re-creating *Grindin'*.

Mass hysteria is all about timing
and you seem to always
have your eye on the clock
and your finger on the pulse—
or hands on the keys.

Or you're cooking up a potion
that you're throwing on these beats
so that every time we hear them
we become less afraid to dream—
more motivated to be.

From *One Hand to Another*,
you keep passing us the keys
in unforgettable melodies.

The year is 2013,
you've reminded everyone
How to be *Happy*.
What a joy it was to see.

The year is 2022,
and I've been reminded
that *No-one Ever Really Dies*
and legends live forever.
So cheers to eternity.

REVEREND BARBER'S REVIVAL

ODE TO REV. DR. WILLIAM BARBER II

When you realize
that all the labels assigned to us
are tools to keep us divided,
thus making it easier to disenfranchise,
then your eyes become open.

When you speak out
against the labels assigned to us
that are tools to keep us divided,
thus making it easier to disenfranchise,
then your life becomes endangered.

Historically, that's how it works here.

And the good reverend
has made it perfectly clear
that of all the issues
he has battled and beat,
at the top of the list is fear.

He does not find
strength in singularity.
In order to improve our stride
he knows we must move *Forward Together*.

He has proved
we are not destined for solitude.
We are at our greatest in solidarity.
We Are Called to Be a Movement.

And every time America
loses its moral consciousness,
or chokes on the surplus of its original sin,
here comes *Reverend Barber*
to *Revive Us Again.*

Reminding us that poverty
cannot be permanent.
Our sister's struggle is not impertinent.
Our brother's battle is not irrelevant.

You teach us that there is power in numbers,
but also strength in empathy.

Your passion for the people
is worthy of applause,
but the fact your heart
is as big as your cause—
is what continues to leave me in awe.

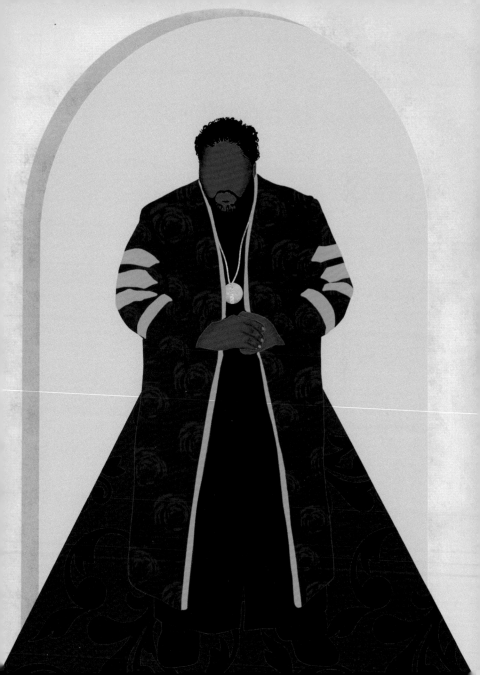

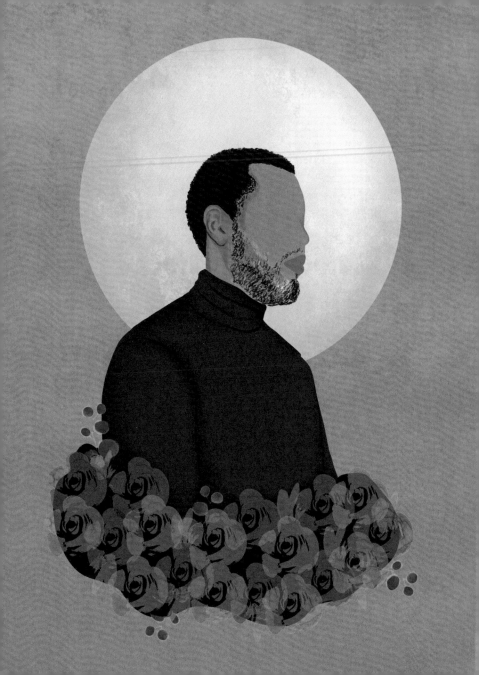

THE CASE FOR TA-NEHISI COATES
ODE TO TA-NEHISI COATES

I wonder if you know
that you write love letters
in their purest form—
raw and organic,
passion in publication.

The type of love that
you don't know if
you should be looking at,
but you can't turn away.

It's a gentle
but persistently erosive love.
One that knows how to listen
but has thoughts of its own.

It has a rhythm,
a flow,
one that only hip-hop knows.

It glides
and grips,
and for those unfamiliar
with the cadence,
it's a Black baptism.

But when they call you savior,
you slide with no answer.
The *Water Dancer*.

The battle to stay hidden,
but transparent
as husband, human, and parent.
What a *Beautiful Struggle*.

Because love ain't always pretty.
Contrarily, it can be combative.
But you keep fighting
with the strength of a *Bison*
and the discipline of a *Panther*.

The most transformative love
has standards.
There are conditions
in which love can be centered.

And you don't let us forget them.
So if you ever question your legacy,
just keep in mind that love letters
are the ones we always remember.

ACKNOWLEDGMENTS

This is for every Black man who has ever inspired me to be better, whether I was fortunate enough to tell them so, or not. Every young Black man who has allowed me to coach or mentor them: Opening yourself to my guidance created a different level of accountability in me, and for that I am forever thankful. Every Black man in *Flowers for the Living* (and formerly in *Black Hand Side* #GramFam): Thank you for being beautiful and believing in me, the power of love, and artistic expression. Every Black man who cheered me on, supported me, reached out, put me on, and saw something in me. Every Black man who protected my name without me knowing. Every Black man who won't know that this book exists: I hope its message and intention reach you in some way. Every Black man who has ever felt out of place, may you find a home in these pages. Every Black man who has found power in his softness and knows that it doesn't make him weak but creates a gracious landing for those who need it. Every Black man who was never taught that we can get further as water than as rocks. Every Black man who was only taught war and never knew peace; know that you deserve love, too. Every Black man who leads and listens. Every Black man who stands when they tell us to sit down. Every Black man who is not afraid to compliment another. Every Black man who passed this book along; it is a baton. Every Black man who found something in this book to go back to. Every Black man trying his best. Every Black man who sees themself as a **Black Oak** from now on. Last, this is for every Black man who will encourage me to keep shining when they see me next—may we all bring out the light in each other.

ABOUT THE AUTHOR

Harold Green III is an ever-evolving artist whose vibrant storytelling and passionate lyrical delivery captivate audiences domestically and internationally. His self-published first collection of poetry (*From Englewood, with Love,* 2014) earned him a prestigious Carl Sandburg Literary Award. Green studied English Secondary Education at Grambling State University, earned a BA in Creative Writing from DePaul University, and an MH in Creative Writing from Tiffin University.

Green specializes in making poetry an accessible art form for all. The architect and curator of *Flowers for the Living*, an annual collaboration project that layers poetry on performances by Chicago's top singers and musicians, his collective was invited to perform in public spaces around the city in a partnership with the Chicago Park District.

He was a featured artist at the Chicago mayoral inauguration and the Illinois Holocaust Museum, has appeared on TEDx and at Aspen Ideas Festival, and has done commissioned work in partnership with major brands and organizations including Nike, Lululemon, Jordan, Google, Chicago Public Schools, and the Chicago Transit Authority.

Green has been featured in the *New York Times*, *Chicago Tribune*, *Chicago Sun-Times*, the *Ellen DeGeneres Show* blog, *Ebony*, Black America Web, *Windy City Live*, and Black Enterprise Web.

He is a proud son, brother, husband, father, teacher, coach, and mentor, all themes reflected in his poetry. He is a visionary, leader, motivator, and an overwhelmingly undeniable human being.

ABOUT THE ILLUSTRATOR

Melissa Koby is a Jamaican-born, Tampa-based illustrator. She fell in love with art at the age of four when her mom gifted her with her very first paint set and easel. Visual art has always been her passion and her default way of self-healing. Her illustrations are a direct reflection of how she feels.

Her work is inspired by her need to process our climate. There are themes addressing social justice, but the underlying themes are always a celebration of people of color, and the peace and tranquility that come from beautiful landscapes. The people in her artwork are faceless because she wants everyone to be able to see themselves in each piece. She wants to normalize looking past the color of skin and wants each viewer to focus on how the art itself makes them feel. All of her artwork is created using a combination of watercolor painting and digital illustration.